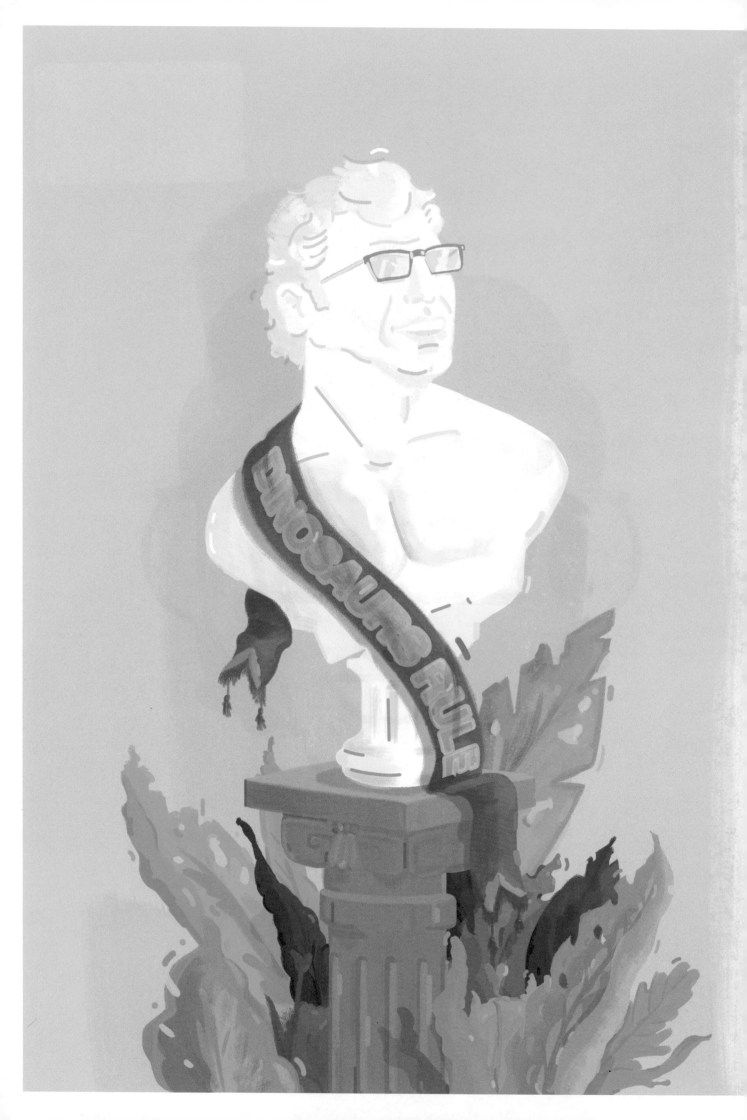

CHAOS

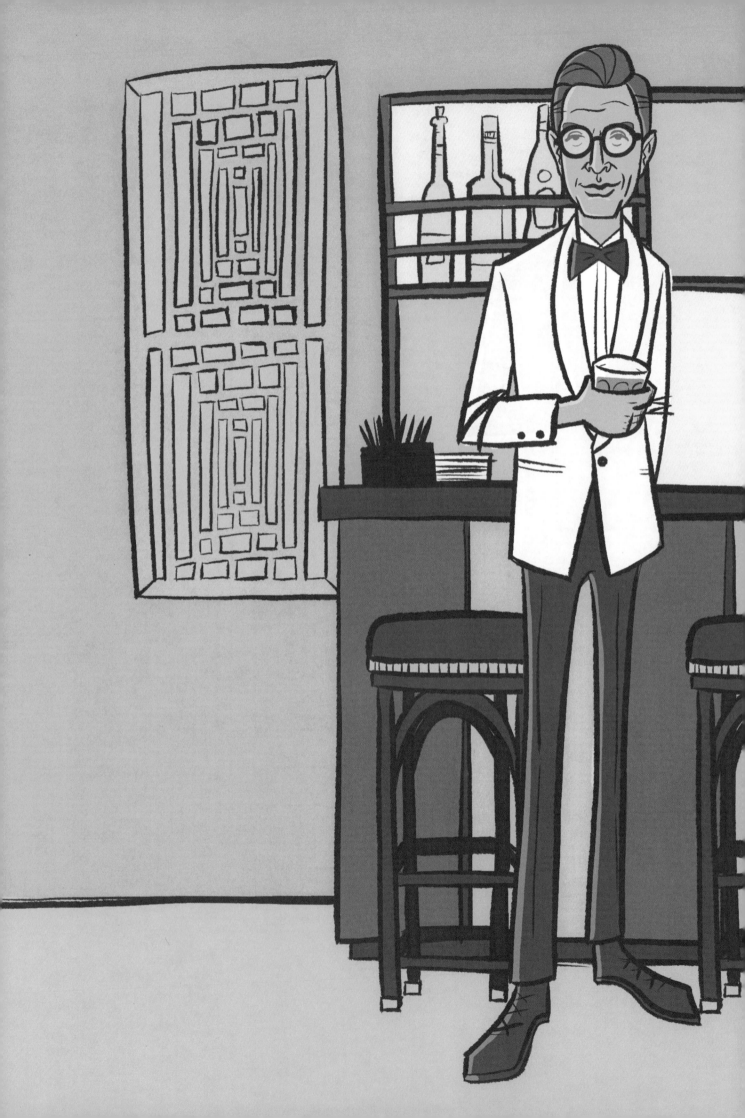

Jeff wants to buy you a drink!
Draw in your drink next to him!!!

Your Emoji Here

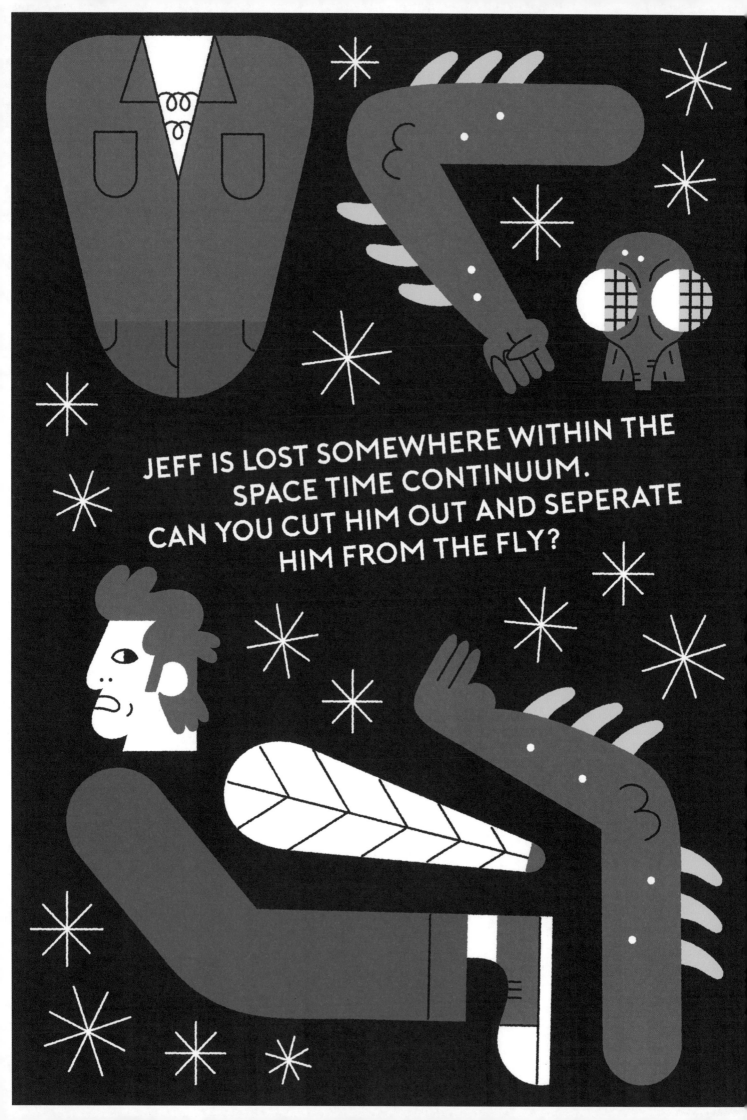

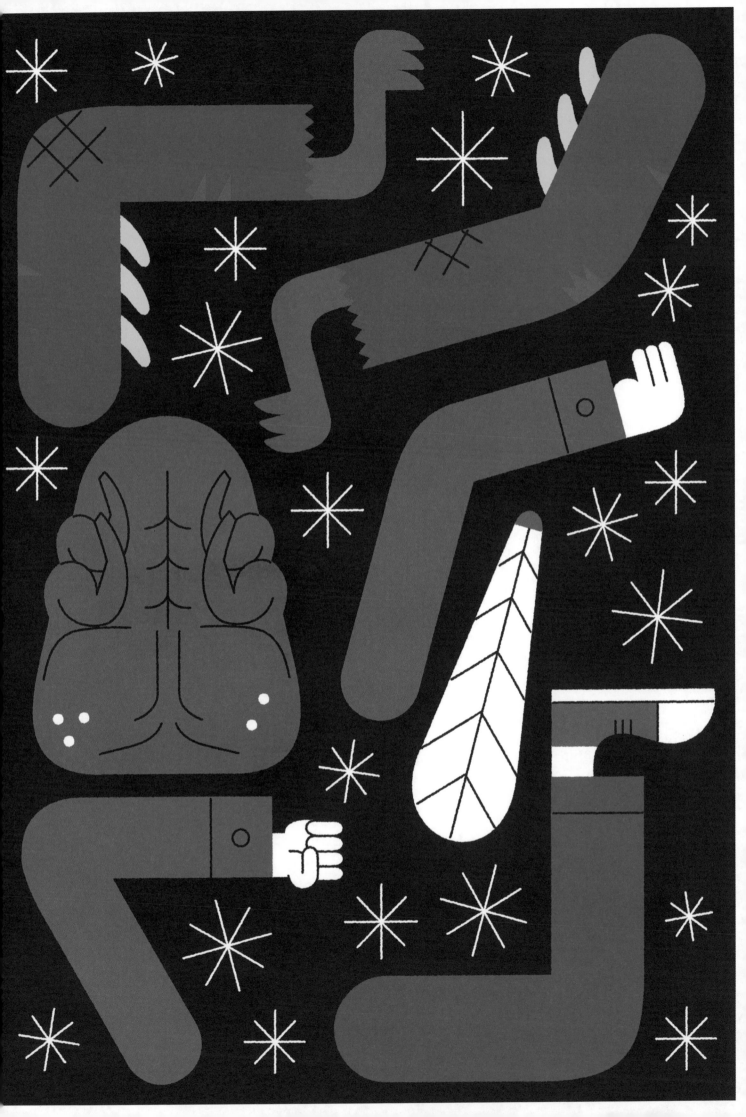

Your Emoji Here

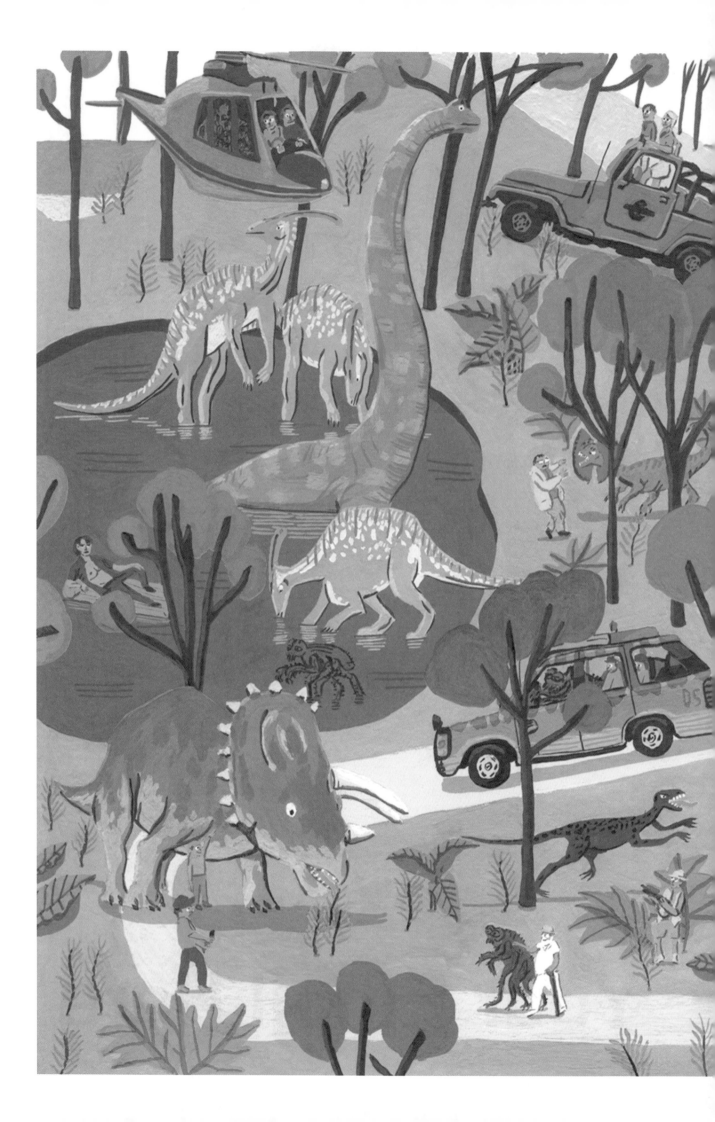

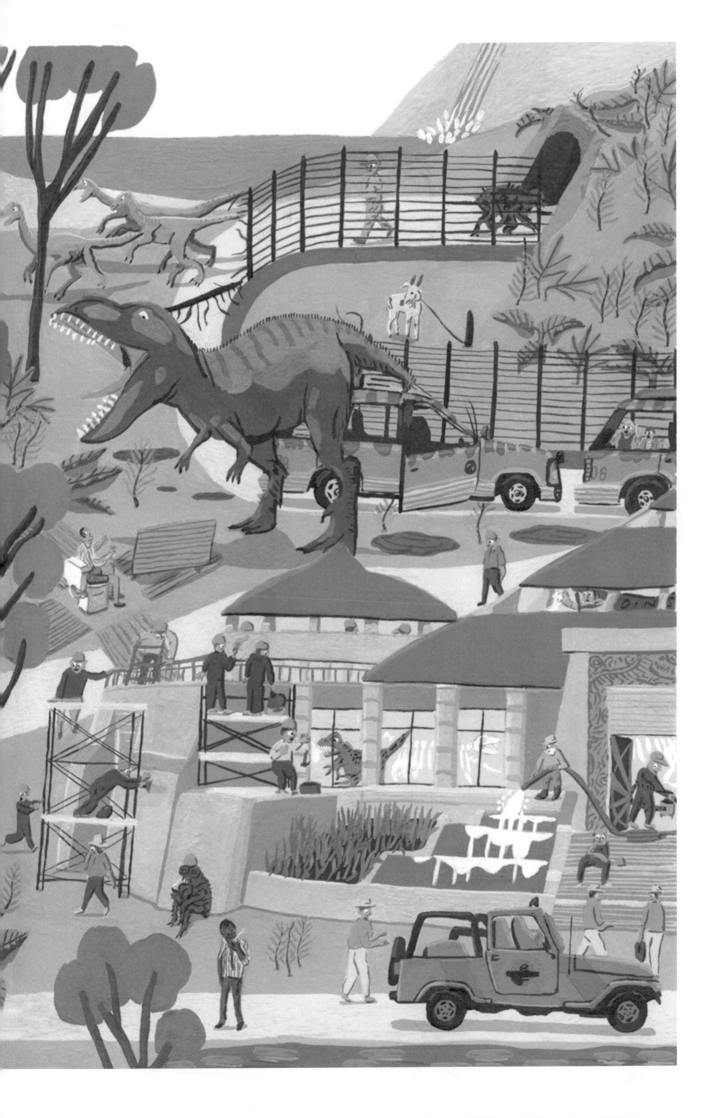

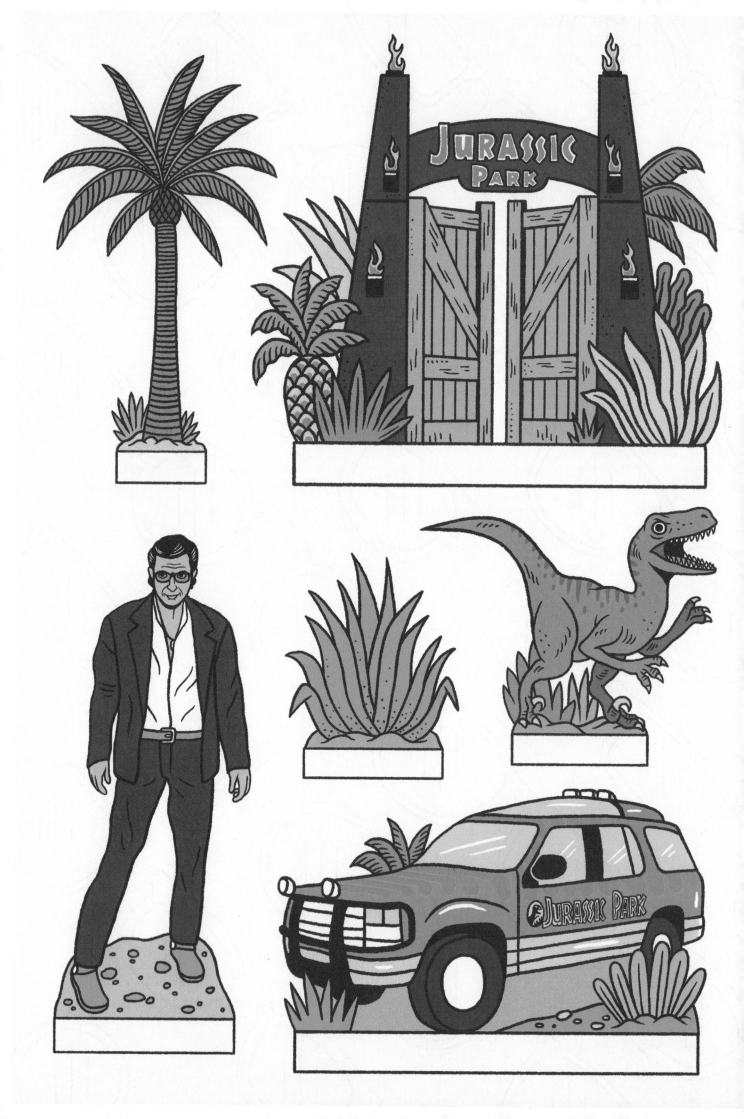

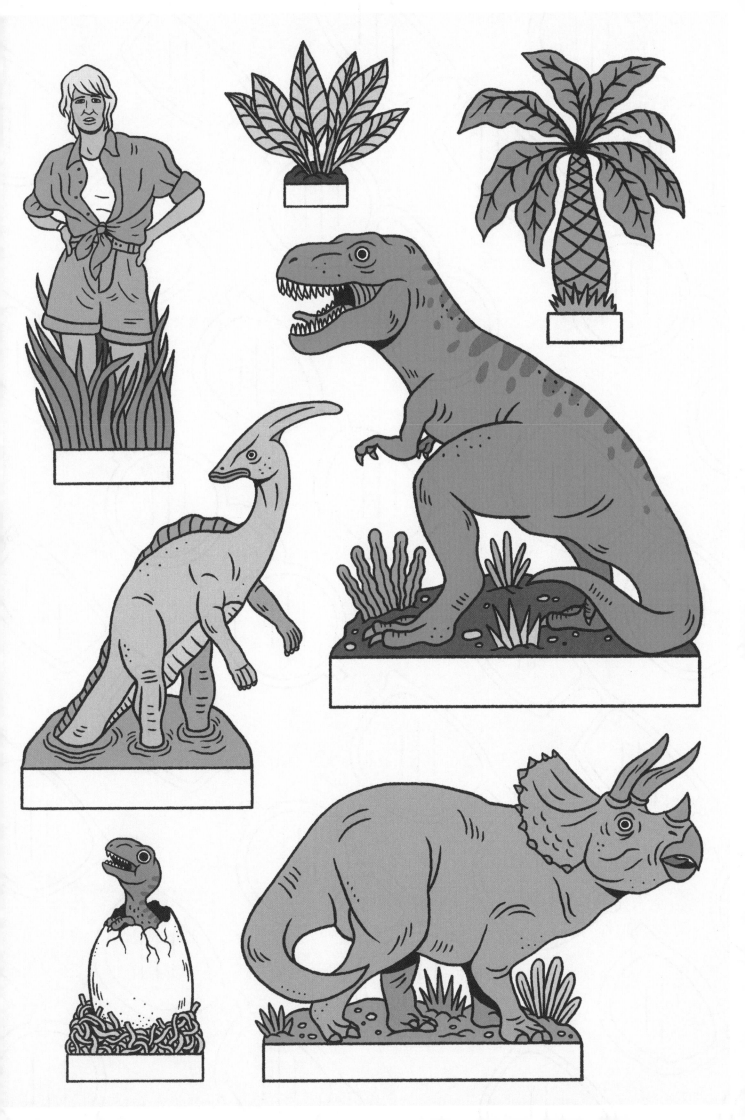

Draw Your Own Yoga Jeff

How many Dinosaurs are there?

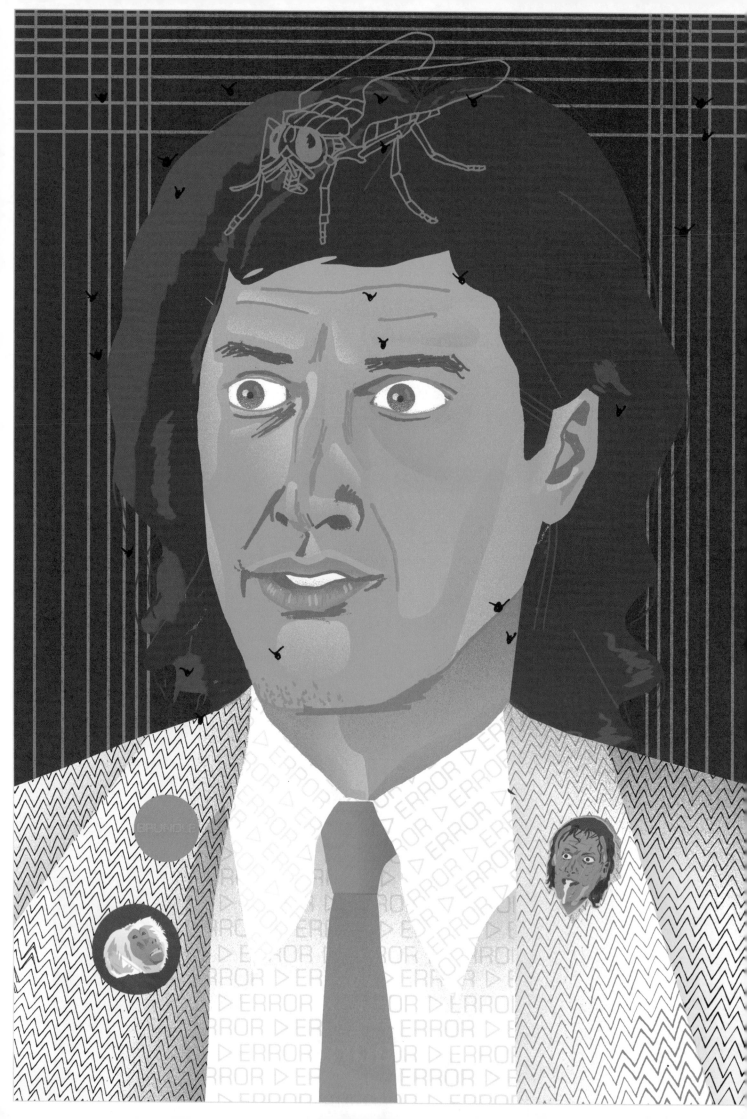

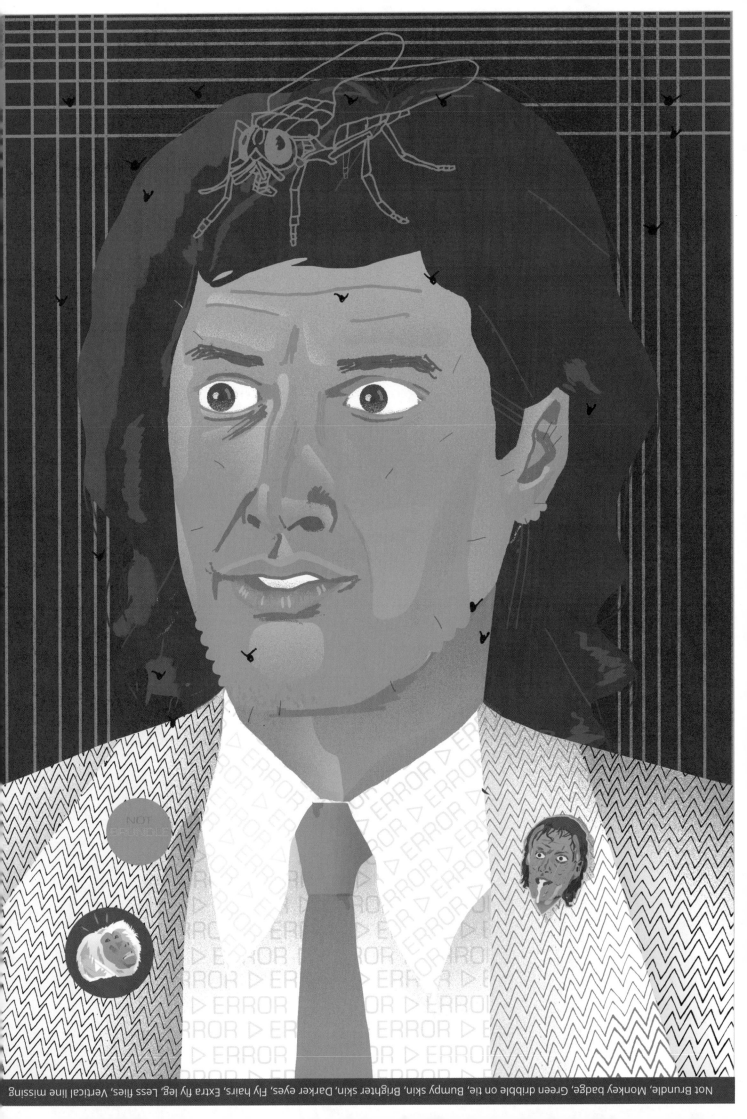

Not Brundle, Monkey badge, Green dribble on tie, Bumpy skin, Brighter skin, Darker eyes, Fly hairs, Extra fly leg, Less flies, Vertical line missing

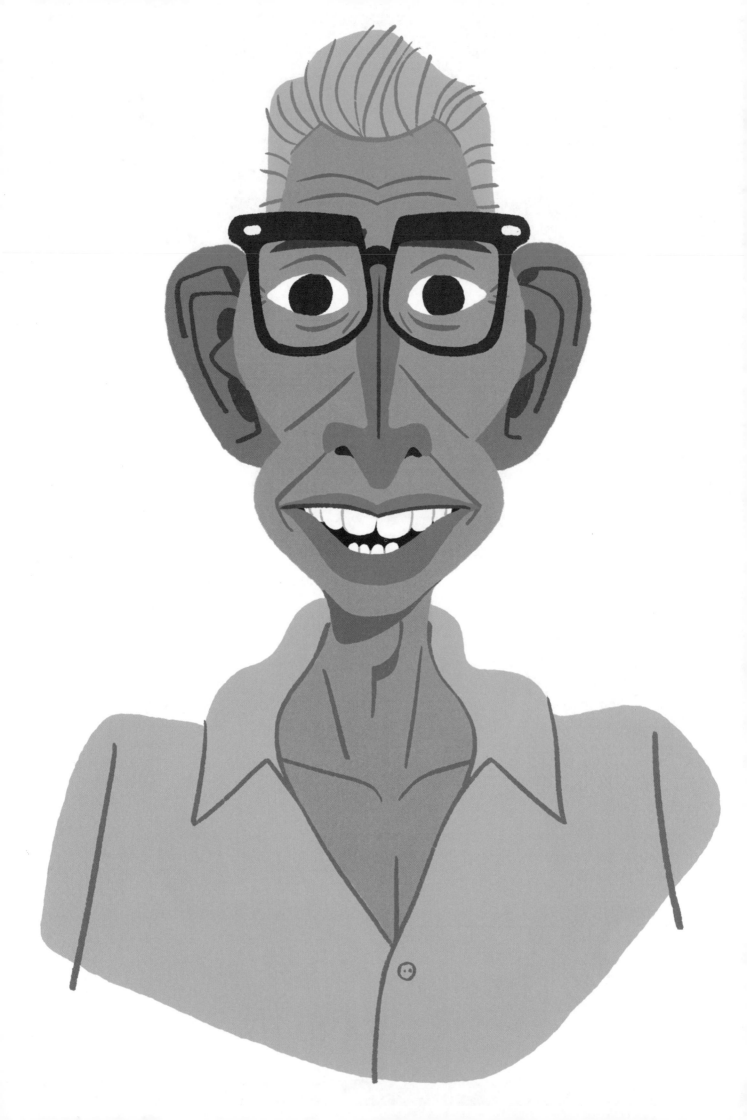

DRAW YOUR FAVORITE
JEFF GOLDBLUM
GLASSES.

—SMAC

Thanks to Janne Livonen, Dan Woodger, Eric Reigert, Henry Kaye, Conner Perry, Bridie Cheeseman, Diraratri HG, Carson Mcnamara, Jack Bailey, Bene Rohlmann, Marja de Sanctis, Michael Driver, Raj Dhunna and Scott MacDonald.